# THE HOLIDAY WINDOW PAINTING BOOK

## HOW TO CREATE COLORFUL HOLIDAY MAGIC

Sarah Craig

**THE HOLIDAY WINDOW PAINTING BOOK**
**Artwork and writing by Sarah Craig**

**Thoughts on the Good Life Press, LLC**
**Copyright 2019**
**ISBN 978-1-7334968-0-3**
**ThoughtsOnTheGoodLife.com**

Brick and Balloon: Cover design, page layout, and graphic design. BrickAndBalloon.com

I, Sarah Craig, retain exclusive ownership of all my original paintings and line drawings contained in this book. However, you have my permission to freely copy, print, and use the 12 black-and-white line drawing template designs for any purpose, personal or professional. The free-use images can be found in this book, printed on full pages, in section one.

The free-use line drawing template designs are also available as PDF files. They are ready for you to email and print. Get the free PDF files at the website below.

TheHolidayWindowPaintingBook.com

**Disclaimer**

This book is for informational and entertainment purposes only. I'm not an artistic, financial, legal, or safety expert. Any advice contained in this book is my opinion based on my own experience. Readers of this book are advised to do their own due diligence when making personal, business, and safety decisions. All information, products, and services provided in this book should be independently verified by your own judgement or qualified professionals. By reading this book and the information presented within, you agree to not hold me or my company responsible for your personal or business decisions, failure, or success.

THE HOLIDAY WINDOW PAINTING BOOK.COM

**Dedicated to:**

# YOU

Thank you for reading this book.
My intention is to empower and inspire you to create holiday window paintings.
You can have a fabulous time and paint beautiful artwork.
As a window painter, you'll joyfully nurture excellence and make the world a brighter place.
It makes me happy to imagine you creating colorful holiday magic.

**Also dedicated to:**

# DENNIS SIMPSON

He's my lovable and multi-talented father.
My dad taught me tons about holiday window painting.
It's been truly magical to paint alongside him.

"If you hear a voice within you say 'you cannot paint',
then by all means paint, and that voice will be silenced."
*Vincent van Gogh*

"I'm trying to make paintings like giant musical chords,
with a polyphony of colours that is nuts but works."
*Roy Lichtenstein*

"Art doesn't transform. It just plain forms."
*Roy Lichtenstein*

# TABLE OF CONTENTS

**THE HOLIDAY WINDOW PAINTING BOOK**

# INTRODUCTION

Holiday window painting is all about creating colorful holiday magic. It's a wonderful skill you can use to make the world a brighter place. You've probably seen holiday window paintings in your community. These are the festive painted scenes featuring anything from snowmen to flying reindeer, and from Christmas trees to "Season's Greetings".

This book will transform you - or "just plain form" you - into a holiday window painter. Window painting might seem complicated. But with the templates and methods provided in this guide, you can relax, enjoy yourself, and follow simple, step-by-step instructions. By learning this window painting system, you are setting yourself up for success. This how-to guide focuses on indoor window painting as a hobby. Painting indoors, you'll stay warm, dry, and comfortable.

This system is perfect for anyone who loves art, holiday enthusiasts, teachers and students, parents and kids, creative entrepreneurs, and business owners - anyone who'd like to paint windows. The picture examples in this book are largely winter holiday and Christmas themed, because I'm drawing from my own personal window painting experience. However, I want to be extremely clear that this is a book for people of all cultures. Take my ideas and use them however you want to celebrate your favorite holidays and traditions!

Everything you need to begin holiday window painting is right here in this detailed system: a list of necessary art supplies, free template design files, encouragement to spark your creativity, and step-by-step painting instructions.

I love holiday window painting. It's an analog art form in a digital world. My wonderful father taught me how it's done. He's a talented window painter. We've painted together and independently. It's a challenging type of art, but ultimately window painting is a delight. Holiday window painting is a prized happiness-inducing skill I'll always keep in my back pocket. It's become a family tradition. In fact, my young son painted his first window at two years old.

I love having this painting skill ready-to-go all year around. I've painted windows mainly for Christmas, Halloween, and Easter. Some of my paintings have been more seasonal, rather than holiday-based. Most of my holiday window painting has been just-for-fun at home, but I have done some professional painting jobs too.

I'd describe my own window painting designs as vibrant, gleeful, and simple. I find a lot of my painting inspiration comes from pop art, cartoons, and nature. I'm inspired by celebrations, inclusivity, expansion, and by the idea of living a good life. My all-time favorite famous artists are Andy Warhol, Roy Lichtenstein, Scott Adams, and Dr. Seuss. I love how their artwork comments playfully on modern life in bright color. Also, it's fantastic they've all enjoyed commercial success during their lifetimes.

Inspired by pop art, I try to bring that same over-the-top, optimistic, clever approach to window painting. It's a fun way to be a painter, especially if you love art and rich colors. For some people, art is easy or at least somewhat easy. Art comes naturally to them. But I have to work hard to produce good art. It's real work for me, but it's relatively fun work. That's why I see art as a labor of love. I love many kinds of art. However in this book, I focus exclusively on holiday window painting for the pure joy of it.

**A window painting doesn't have to be perfect to be whimsical and wonderful.** I always keep that in mind while painting. **Perfection is not required. Window paintings can be excellent and perfectly imperfect at the same time.** My skills get better every time I paint a window, and yours will too.

**When learning how to do holiday window painting successfully, it helps to have a window painting system to simplify the process. In this book, I'll describe a step-by-step system for indoor window painting using washable tempera paints.** You'll love painting on the indoor side of the glass, because you and your artwork will be in a warm, dry, controlled environment no matter the weather outside. That's worth a lot in the winter. Plus, indoor window paintings look great, and they're nicely protected from outdoor wear-and-tear. Indoor tempera window paint is easy to remove, which is good. It's a win-win-win scenario.

I want this book to be a valuable resource for you. I've considered many practicalities. I explain how to create full-size window painting design templates. You can use these paper design templates to trace the line drawings onto windows with a paint pen. Then you can fill in the line drawings with a paintbrush and colorful tempera paint. It's like coloring in a coloring book picture with paint.

But even if you never paint a window, this book is still for you. My hope is this book will somehow enhance your life, energize you, make you feel good, and inspire you to dream and take smart new artistic risks. I'm here to support you and wish you the best.

If you do want to paint windows, I encourage you to develop your skills quickly, so you can start holiday window painting right away. On the other hand, it's okay to take your sweet time and learn how to do window painting over the course of a lifetime. Or just use this book to daydream about possibilities, and that might lead to action. Do what's best for you. It's totally your choice. Window painting is evergreen.

This book takes you through an entire step-by-step window painting system which you are free to use in its entirety. You are also welcome to be selective with this book and pay unbalanced attention to your favorite parts.

You should go as big or as small as you want with holiday window painting. I want you to feel empowered by having an artistic - and pleasant - way to create colorful holiday magic.

Holiday window painting can create rich life experiences. I know this personally. I especially love painting with my dad and brightening up lives with painted holiday cheer. The good experiences and memories are plentiful. I enjoyed window painting in years past, I do now, and I will in the future. I love painting just for the intrinsic thrill. I get a thrill painting at home, oftentimes in just my own good company, and sometimes in the extra good company of my husband, son, and cat. It lights up my world every time my son says, "I love your painting!" The good memories are abundant.

I wrote this how-to book so that you can create delightful experiences of your own. It's an opportunity to expand your unique artistic skills and create whimsical, winning, personality-filled art. The possibilities are endless!

With the simple instructions in this book, you'll become a holiday window painter. You only need a few supplies, basic artistic skills, and a willingness to learn. My goal is to empower you by giving you everything you need to get started, succeed, and create your own devastatingly charming holiday window paintings!

ALL THE BEST !

Sarah Craig

# SECTION ONE
# PREPARING FOR MAGIC

## PAINTING FOR THE PURE JOY OF IT

## SUPPLIES FOR INDOOR WINDOW PAINTING

## HOLIDAYS PERFECT FOR PAINTING

## FREE TEMPLATE DESIGNS & WINDOW PAINTING PHOTOS

# PAINTING FOR THE PURE JOY OF IT

Holiday window painting can be a fantastic experience. If you're going to paint windows, it's absolutely essential to allow yourself to derive some genuine joy from the artistic activity. Indoor window painting can be fun for anyone who wants to pick up a paintbrush and give it a try. That includes craft hobbyists, families, teachers and students, business owners, and people who just like to explore art. You can even paint professionally. Any which way, you'll love holiday window painting, just for the pure, simple joy of it. You'll experience many abundant benefits. I've listed some of them below.

**Delightful Results:** Window paintings are colorful, whimsical, pleasing, and all about holiday cheer. Your artwork will generate jolly feelings and festivity.

**Artistic Expression:** It's a unique way to express yourself. Window painting is a chance to use vivid colors to get into the creative flow and produce winsome art.

**Good Experiences:** It's rewarding to complete holiday window paintings. You can paint by yourself, or you can paint alongside family and friends. As you paint, you'll create beautiful experiences.

**Holiday Magic at Home:** Your window paintings will add an exciting extra dimension to your home holiday decorations, alongside your usual traditions. You'll delight your family, neighbors, and houseguests with your brilliant, colorful, festive paintings.

**Community Delight:** Brighten up the holidays with window paintings at your workplace, your school, your business, your place of worship, or the homes of your family and friends. Not many people know how to paint windows. You'll surprise and inspire people with your unexpected "superpower".

**Learning Opportunities:** Window painting is an interesting artistic challenge. It's difficult but doable. Glass is a "canvas" most painters haven't experienced. It's a chance to explore color, light, patience, organization, and workflow, all culminating in beautifully finished works of art to admire and enjoy.

**Business Opportunities:** Making money can be fun. Consider window painting professionally. You can sell your window painting services and paint storefronts in your community. Some professional window painters paint just during the winter holidays, while others do the work year round. Some of these pros paint the indoor side of windows, some paint outdoors, and some do both. If you are already a business owner, with a storefront of your own, you can save money by painting your own windows, instead of hiring someone else.

**Warm Coziness:** This book primarily focuses on indoor window painting as a hobby. A major benefit of indoor window painting is that you will be working indoors, no matter the weather. You can stay warm and toasty, with a mug of something hot, while you paint.

Now, let's prepare to create some colorful holiday magic!

# SUPPLIES FOR INDOOR WINDOW PAINTING

The supplies you'll need to start holiday window painting are relatively inexpensive, compared to some other artistic hobbies. Get creative and look for supplies you already have around your house. Then buy or make anything you still require. All the basic window painting supplies you'll need are pictured below.

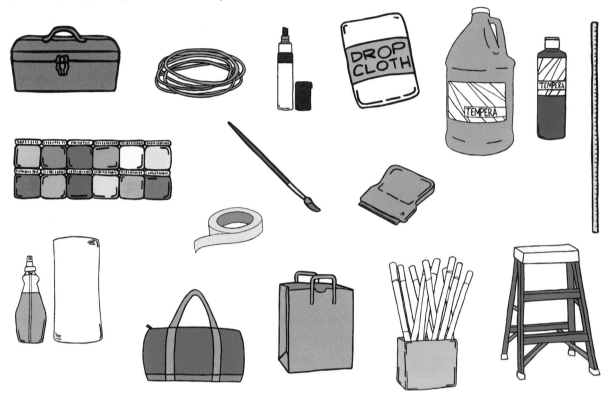

The painting supplies available on the market are constantly changing and evolving. Because of that, I'm not recommending specific brands in this book. Choose the brands you already love or go to TheHolidayWindowPaintingBook.com for my current brand recommendations. I'm constantly searching for the best supplies.

**YOUR PAINT TOOLBOX**

Most of your holiday window painting supplies will fit neatly inside a toolbox.

**Paint Toolbox:** Find a simple, sturdy metal or plastic toolbox [Figure 1]. You'll use it to store and carry supplies like small jars of paint, brushes, paint pens, masking tape, and rubber bands. The perfect tool box size is approximately 16" x 7" x 7". You can store 12 small paint jars in the bottom layer. Choose a toolbox with a top tray, so you can stack your other supplies neatly on top of your paint.

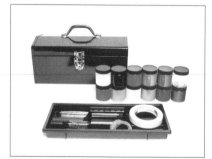

Figure 1: Paint Toolbox

**Tempera Paints:** For indoor window painting, use washable tempera paint. Even high-quality professional brands are inexpensive. Get a set of at least 11 basic colors: red, orange, yellow, green, blue, purple, white, black, magenta, turquoise, and brown. Carefully choose a non-toxic, washable tempera paint that's thick, creamy, and vibrant in color. Quality paint will enhance your paintings dramatically. It's key. Paint doesn't need to be expensive, but it should be carefully chosen. For best value, buy pint size [Figure 2] or gallon size [Figure 3] bottles of paint, then fill and refill smaller containers.

Figure 2:
Pint Size
Paint Bottle

Figure 3:
Gallon Size
Paint Bottle

**Reusable 4-Ounce Paint Jars:** Fill small reusable jars [Figure 4] with each paint color to carry in your toolbox [Figure 5]. You can find 4-ounce clear plastic jars online, or reuse glass baby food jars. When you're painting, just dip your paint brushes straight into these small jars. You can also keep a backup supply of pint size bottles of paint colors you use a lot. Also, keep at least one extra small empty paint jar in your toolbox [Figure 6], so you can mix paint anywhere [Figure 7].

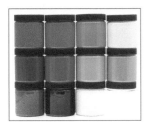

Figure 4: Reusable
4-Ounce Paint Jars

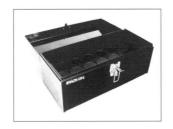

Figure 5: Toolbox with
Small Paint Jars

Figure 6: Extra
Empty Paint Jar

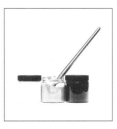

Figure 7: Mix
Paint in Extra Jar

**Washable Paint Pens:** Trace designs from templates to windows using washable black or white paint pens [Figure 8]. Look for 8mm broad tip paint pens. You'll love how they draw thick, opaque lines on windows [Figure 9]. Alternative pen options include black or white liquid chalk markers or black dry erase markers. Whatever you choose, use a high-quality brand that easily washes off windows. Test their washability.

Figure 8: Paint
Pen

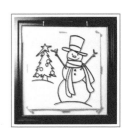

Figure 9: Draw Lines
on Windows

**Paintbrushes:** Get an assortment of round watercolor brushes in various sizes [Figure 10]. Paintbrush "size 4" is the most useful in my experience. It's also great to have paintbrushes in sizes 2, 3, 5, and 6. You can buy inexpensive, decent-quality brush sets, in assorted sizes, that hold paint well, create smooth strokes, and don't shed bristles. It's good practice to reserve several brushes each for white paint only, black paint only, and in-between colors only. But in reality, I use all my paintbrushes for all colors; I just wash them really well with plain water in a sink. Experiment and do whatever works best for you!

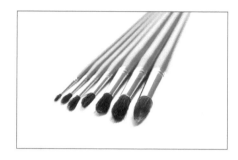

Figure 10: Paintbrushes

**Rubber Bands:** Use rubber bands to keep your templates rolled up [Figure 11]. Keep some extras handy.

Figure 11: Rubber Bands

**Masking Tape:** Use masking tape to attach templates to windows [Figure 12]. It's easily removable from windows and templates.

Figure 12: Masking Tape

**Razor Blade:** It's helpful to have a razor blade handy [Figure 13]. You can use it as a tool to selectively scrape off paint, when you make a small mistake, or when the paint drips. Safety razors are great, because the sharp edge can be concealed for your protection, and they have a sturdy plastic grip. Still, be cautious when storing razors, as they should be kept away from children.

Figure 13: Razor Blade

## YOUR DESIGN TEMPLATES

**Design Template Box:** A wine case box is perfect for holding rolled up design templates [Figure 14]. Most wine case boxes include cardboard dividers, which create 12 handy spaces for rolled up paper design templates. You can cover your design template box in cheerful wrapping paper.

Figure 14:
Box of Rolled Up
Design Templates

**Design Templates:** Print full-size design templates on big sheets of white paper [Figure 15]. Store your rolled up templates in your design template box. This book includes 12 free-use template designs as black and white line drawings later in section one. Simply take this book to a print shop and ask for enlargements of the line drawing designs on sturdy white paper. Have the images printed in reverse, as mirror images, so they appear backward on the templates. Consider laminating your paper design templates for extra durability. You can also access the free template design files in PDF form at TheHolidayWindowPaintingBook.com. Print your templates 28" on the long side for a nice fit on most windows. For larger paintings, print your templates 42" on the long side. The length of the template short side will vary depending on the design proportions. You can also create templates from your own original line drawings.

Figure 15:
Design Template
Taped to Window

**Yardstick:** A metal yardstick (or meterstick) is useful when placing a design template on a window with precision [Figure 16]. It's also very nice to have a yardstick to draw guidelines for freehand lettering on the outside of the glass.

Figure 16: Yardstick

## YOUR OTHER PAINTING SUPPLIES

**Drop Cloth:** Protect your painting area floor and windowsill with a drop cloth or sheet.
**Paper Towels and Cleaning Spray:** Clean off windows with paper towels and cleaning spray before you start painting, and when you're removing a painting.
**Supply Bag or Box:** Use this to carry your drop cloth, paper towels, and cleaning spray.
**Garbage:** Keep a garbage can, or a paper or plastic bag, handy to help avoid messes and dispose of paper towels covered in paint and dirt.
**Step Ladder:** A small step ladder or footstool is essential for reaching the top portion of taller windows. A step ladder can double as a stool to use while you paint. You might want to use a full-size ladder too, especially tall windows, but only if you feel comfortable and safe. Follow the warnings and instructions for any ladder you purchase and use one only if you are physically capable of doing so.

I'll mention again that you can save money by using supplies you already have whenever possible. With that being said, there are many great companies through which you can buy painting supplies. Products are constantly changing and evolving. See my current brand recommendations at the following website: TheHolidayWindowPaintingBook.com

# HOLIDAYS PERFECT FOR PAINTING

**WINTER HOLIDAYS AND CHRISTMAS**

The most common time of year for holiday window painting is definitely winter. The paintings in this book largely focus on Christmas, because that's where I personally have the most painting experience. I've also included paintings that celebrate the general splendor of winter, which I hope you'll enjoy if Christmas isn't a holiday celebrated in your community. You can customize your window paintings for any winter holiday you celebrate: Hanukkah, Kwanzaa, Christmas, New Year's, any other holiday, or the winter season.

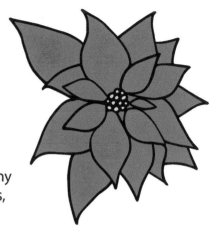

**WINTER HOLIDAY DESIGN IDEAS**

**Christmas:** Snowman and Tree (Page 19); Santa (Page 21); Reindeer (Page 29); Tree (Page 23); Daddy and Son with Tree (Page 25); Car and Tree (Page 27); Presents on Sled (Page 31); "Merry Christmas" (Page 37); Elves; Mrs. Claus; Ornaments; Candy Canes

**Hanukkah:** Menorah and Candles; Dreidels; Star of David; "Happy Hanukkah"

**Kwanzaa:** "Happy Kwanzaa"; Feast of Food; Candles in Red, Green, and Black

**New Year's:** Fireworks; Champagne Bottle and Glasses; Clock at Midnight

**Winter Holiday Season:** Snowman; Snowflakes (Page 50); "Season's Greetings" (Page 39); "Happy Holidays" (Page 41); Wreath (Page 33); Holly; Mistletoe; "Joy" with a Snowman as the "O" (Page 35); Poinsettias; Secret Terry

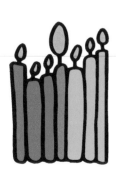

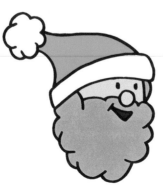

## OTHER HOLIDAY AND SEASONAL DESIGN IDEAS

Window painting can create colorful holiday magic all year long. Don't stop at winter! You can potentially paint according to different themes every month of the year. I've listed some promising holidays, seasons, and corresponding design ideas below. Feel free to add your own holidays and ideas to the list.

**Valentine's Day:** Multicolor Hearts; "Love" written in a Heart; Red Roses; Cupid

**St. Patrick's Day:** Four-Leaf Clovers; Leprechaun; Pot of Gold; Rainbows; Green Beer Cheers

**Easter:** Decorated Eggs; Basket; Easter Bunny; Chicks; "Happy Easter"

**Spring:** Flowers; Grass; Butterflies; "Spring is Here!"; Sunshine; Flowering Trees; Birds

**Summer:** Sun; Palm Trees; Beach; "It's Summer Time"; Watermelon; Bees; Beach Ball; Colorful Umbrella

**4th of July:** Fireworks; Sparklers; American Flag; "Happy Independence Day"

**Halloween:** Candy; Jack-O'-Lanterns; Ghosts; "Trick-or-Treat"; Haunted House with Moon and Bats; Witch on Broom; Skeletons; Black Cats; Spider and Web

**Thanksgiving:** Colorful Turkey; "Give Thanks!"; Cornucopia; Pumpkin with Vine

**Fall:** Autumn Trees; Multicolor Leaves; Sunflowers; Rain; "Hello Autumn"

**Birthdays:** Presents; Birthday Cake; Cupcake; Lit Candles; Confetti; Party Hats

# Free Template Designs & Window Painting Photos

It's easiest to do holiday window painting using reusable paper design templates, which you can tape to windows and trace. You don't have to draw designs freehand.

You are welcome to create templates by making large prints of the 12 free-use template design line drawings, which are later in this section of the book [Figure 17].

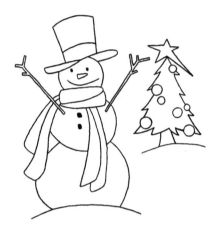

Figure 17: Free-Use Template Design

Just take this book to a printer and ask them to make enlarged prints of the line drawings. You have my permission. **Keep in mind, most images you'll find in other books, online, and elsewhere are copyrighted and restricted from copying, printing, and commercial use.** But you can freely copy, print, and use the 12 line drawings in this book for any purpose, including commercial, without giving me credit.

You can also create templates of your own original designs and lettering. Try using tracing paper and a high-quality fine-tip black pen to perfect your small original drawings. Then have a printer enlarge your designs to create paper templates.

When creating templates, carefully choose a printing service based on price and quality. Look for print shops that routinely produce large blueprints and banners for professionals. In my experience, that's where you'll get the best bang for your buck: high-quality image scans, affordable large prints, and lamination for extra durability. IMPORTANT NOTE: Have the line drawings printed in reverse, as mirror images, so they appear backward on the paper templates. This will allow you to trace the backward image onto the inside of glass windows. The image will appear correctly oriented outside. This is especially important with lettering, which should read backward inside, and read correctly outside.

All 12 line drawing template design files in this book are also available online. These PDF files are free, free-use, and can be emailed to a printer. All files contain a message of permission to print. Find these free design template PDF files at the web address below.

TheHolidayWindowPaintingBook.com

When having your templates printed, you can print any size you want [Figure 18]. However, the following two template sizes are especially useful for common window sizes:

**28-inches on the long side: Medium.** This a good size for a variety of medium-size windows and glass doors. All the painting examples in this book were painted with 28" templates on a 35" square window. This template size is also handy if you want to paint multiple designs on the same window, for example, when combining a picture and lettering. The template short side lengths will vary depending on the design proportions.

**42-inches on the long side: Large.** It's nice to have large templates too, so you can fill bigger windows with your paintings.

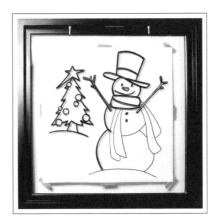

Figure 18:
Printed Template Taped to Window

Here are a couple additional options, besides using a print shop, for creating templates:

**Hand Draw Templates:** If you're ultra-thrifty and up to the challenge, you can avoid printing costs and hand draw your templates on large white paper. It helps to use grid guidelines.

**Freehand Draw onto Windows:** If you have the rare artistic ability to draw designs directly onto windows without templates, by all means, go ahead. I'm impressed! Draw away!

Templates will make your window painting work a hundred times easier. We'll go over exactly how to use templates later in the book in section two.

Here's an at-a-glance look at the 12 free-use line drawing template designs, as well as the final product: completed window paintings.

## TEMPLATE DESIGN 1: SNOWMAN AND TREE

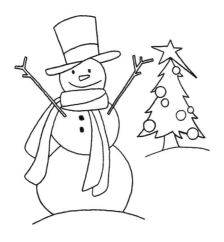

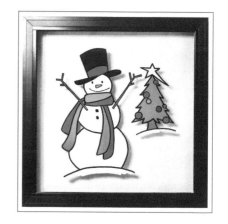

## TEMPLATE DESIGN 2: SANTA

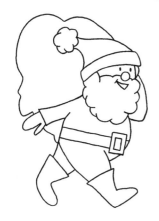

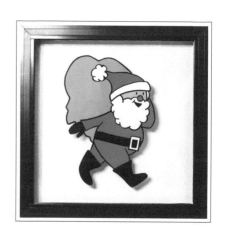

## TEMPLATE DESIGN 3: TREE

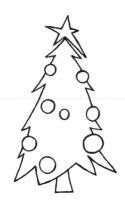

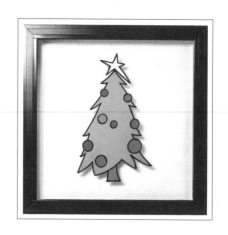

## TEMPLATE DESIGN 4: DADDY AND SON WITH TREE

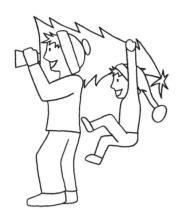

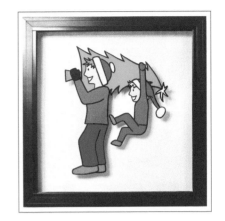

## TEMPLATE DESIGN 5: CAR AND TREE

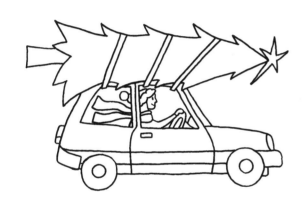

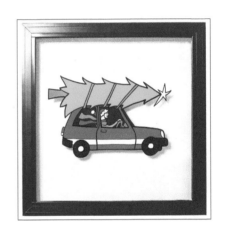

## TEMPLATE DESIGN 6: REINDEER

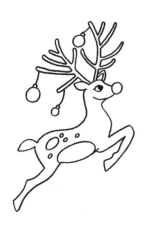

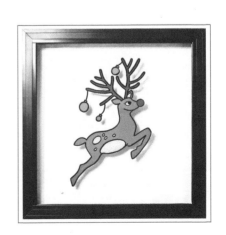

## TEMPLATE DESIGN 7: PRESENTS ON SLED

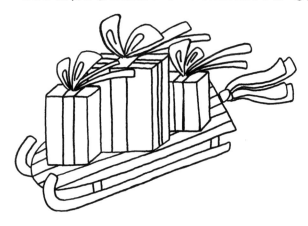

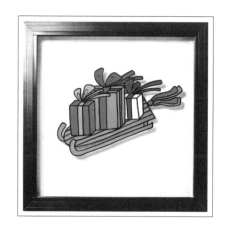

## TEMPLATE DESIGN 8: WREATH

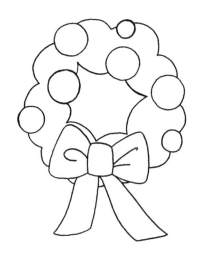

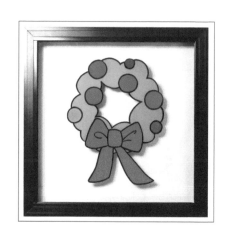

## TEMPLATE DESIGN 9: JOY SNOWMAN

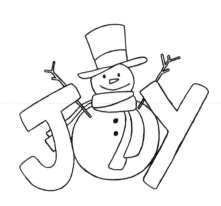

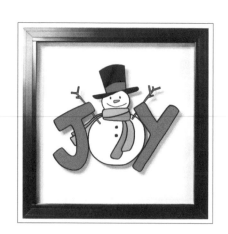

## TEMPLATE DESIGN 10: MERRY CHRISTMAS

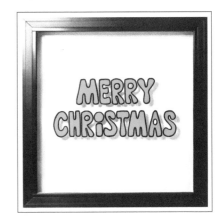

## TEMPLATE DESIGN 11: SEASON'S GREETINGS

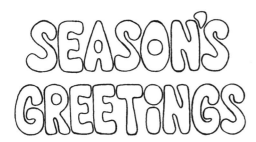

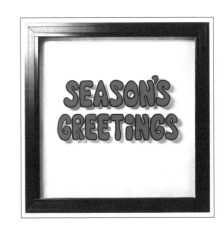

## TEMPLATE DESIGN 12: HAPPY HOLIDAYS

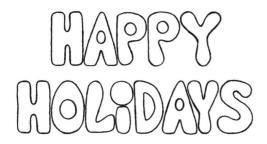

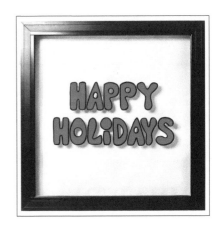

Over the next 24 pages, these same line drawings and completed paintings are featured again on full pages. On the left, you'll find the free-use template design line drawings. On the right, there are 12 corresponding photos of completed window paintings. You can print templates of the line drawings and paint these exact images on the windows in your life.

# TEMPLATE DESIGN 1: SNOWMAN AND TREE

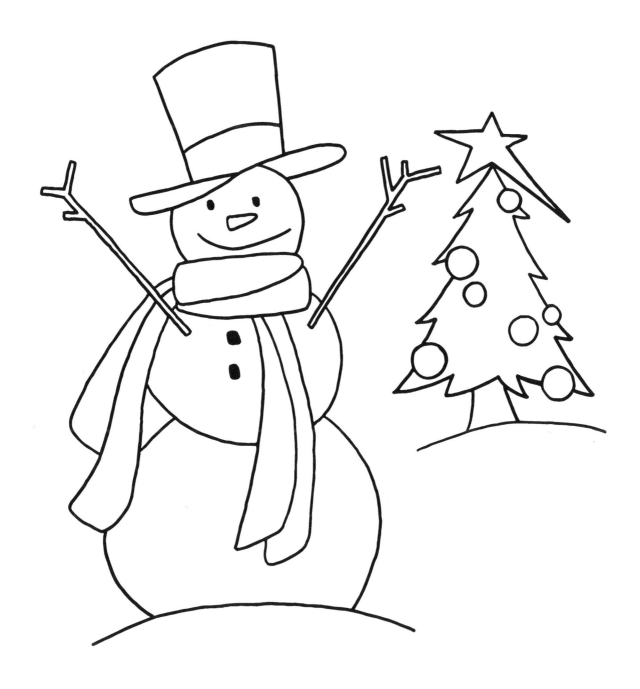

# SNOWMAN AND TREE

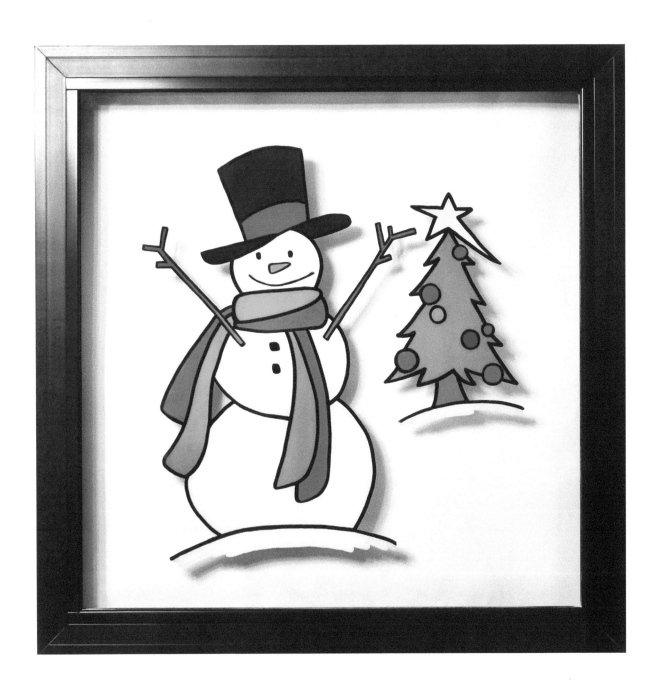

# TEMPLATE DESIGN 2: SANTA

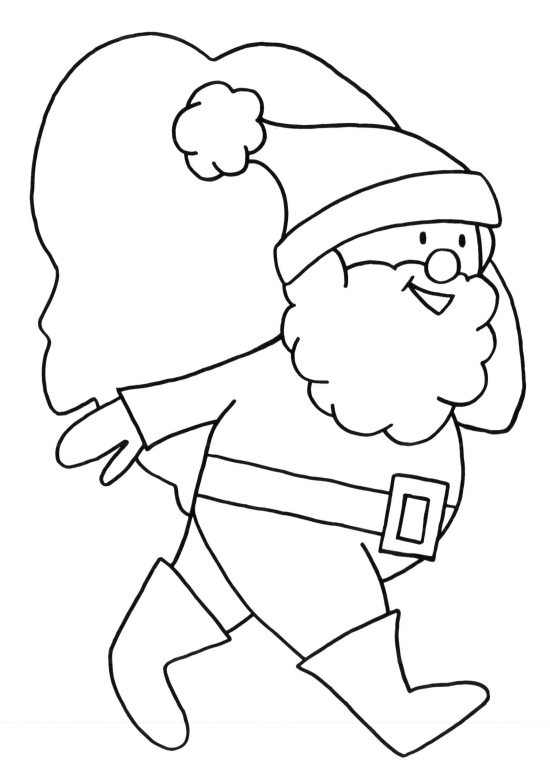

YOU HAVE PERMISSON TO FREELY COPY, PRINT, AND USE THIS IMAGE FOR ANY PURPOSE, INCLUDING HOLIDAY WINDOW PAINTING TEMPLATES.
IMPORTANT NOTE: PRINT THE LINE DRAWINGS IN REVERSE, AS MIRROR IMAGES, SO THEY APPEAR BACKWARD ON THE PAPER TEMPLATES.
SARAH CRAIG, THEHOLIDAYWINDOWPAINTINGBOOK.COM

# Santa

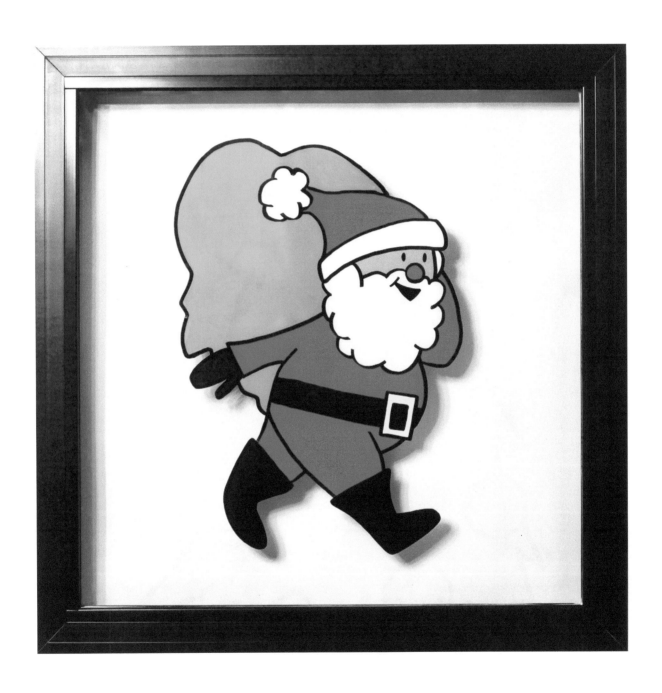

# TEMPLATE DESIGN 3: TREE

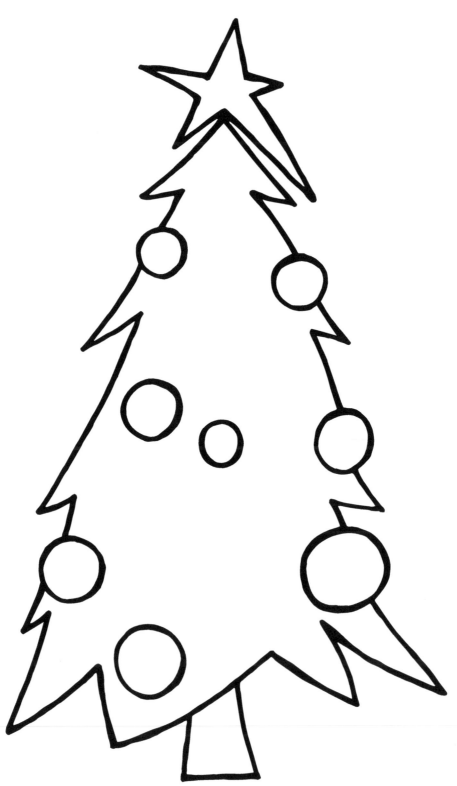

You have permisson to freely copy, print, and use this image for any purpose, including holiday window painting templates.
IMPORTANT NOTE: Print the line drawings in reverse, as mirror images, so they appear backward on the paper templates.
Sarah Craig, TheHolidayWindowPaintingBook.com

# TREE

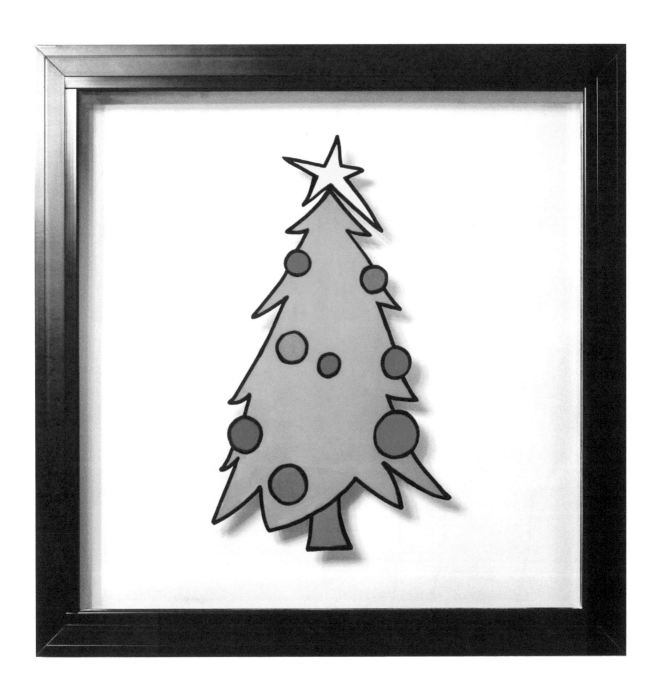

# TEMPLATE DESIGN 4: DADDY AND SON WITH TREE

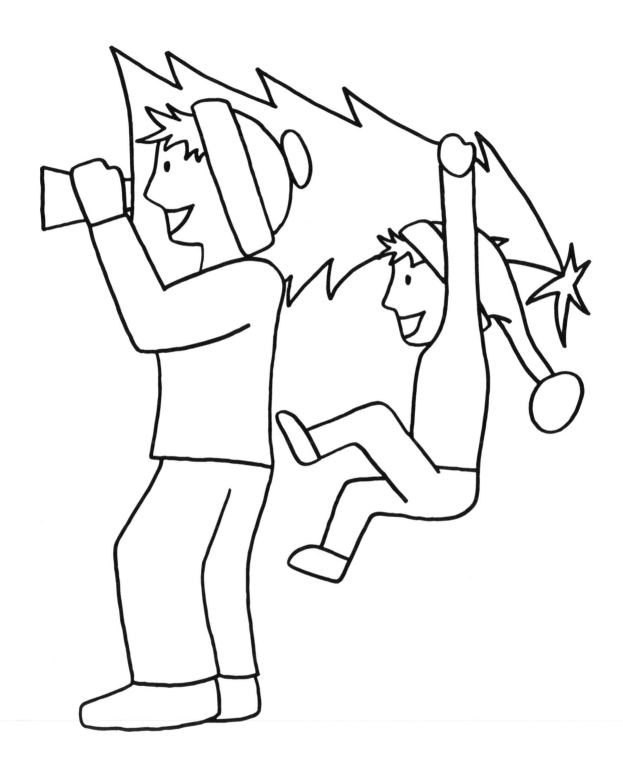

# DADDY AND SON WITH TREE

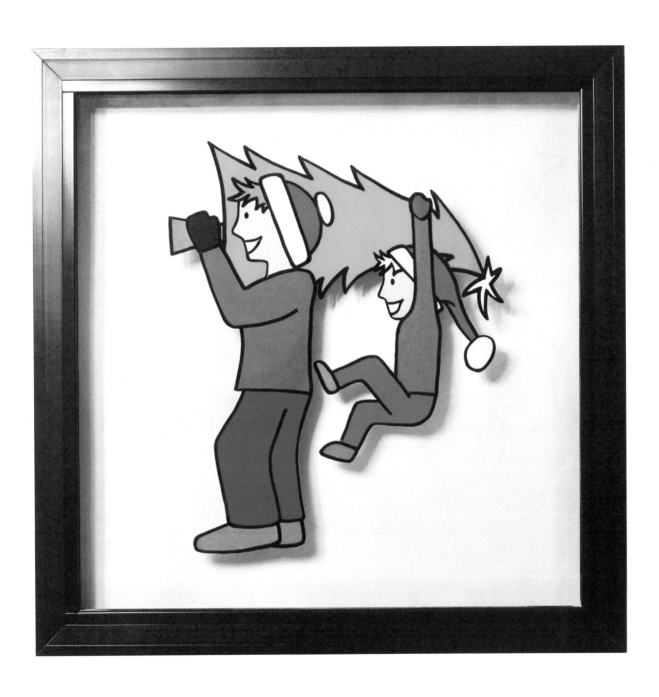

# Template Design 5: Car and Tree

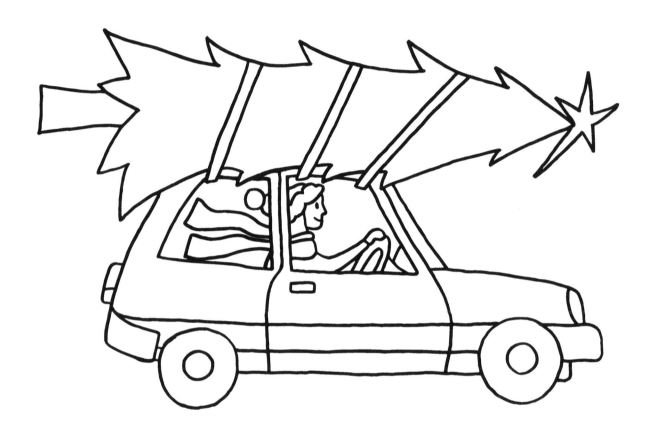

# CAR AND TREE

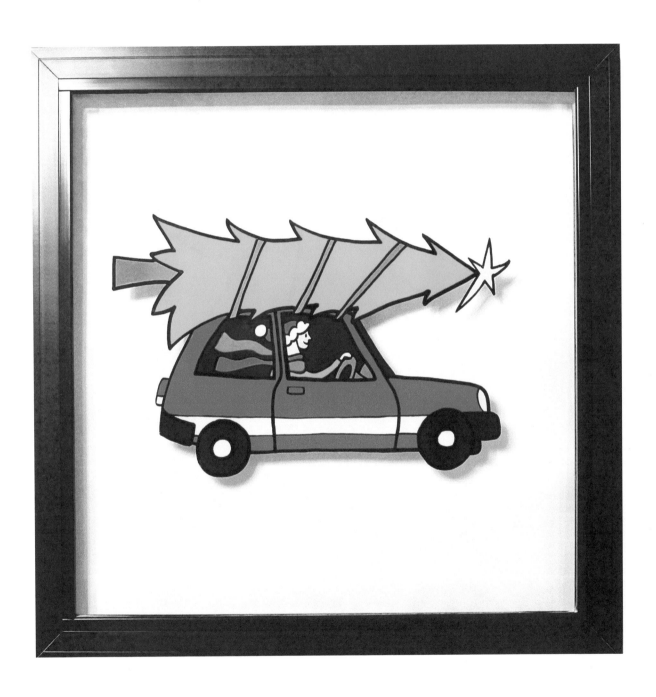

# TEMPLATE DESIGN 6: REINDEER

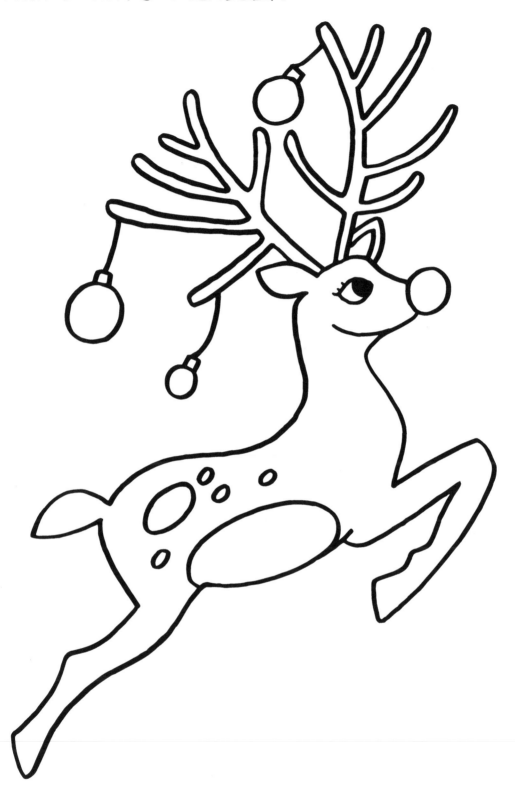

# Reindeer

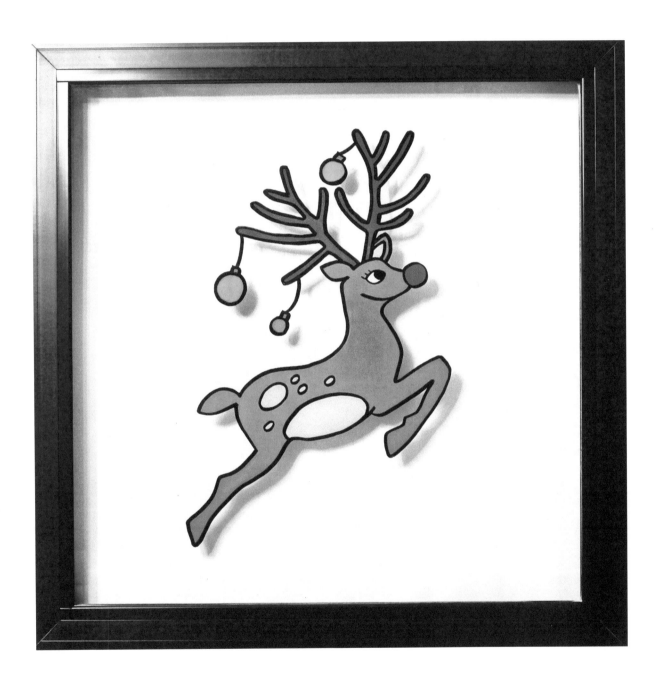

# TEMPLATE DESIGN 7: PRESENTS ON SLED

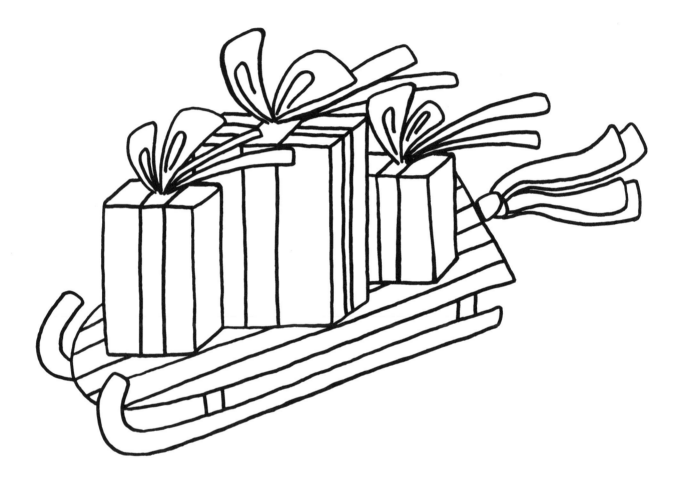

# PRESENTS ON SLED

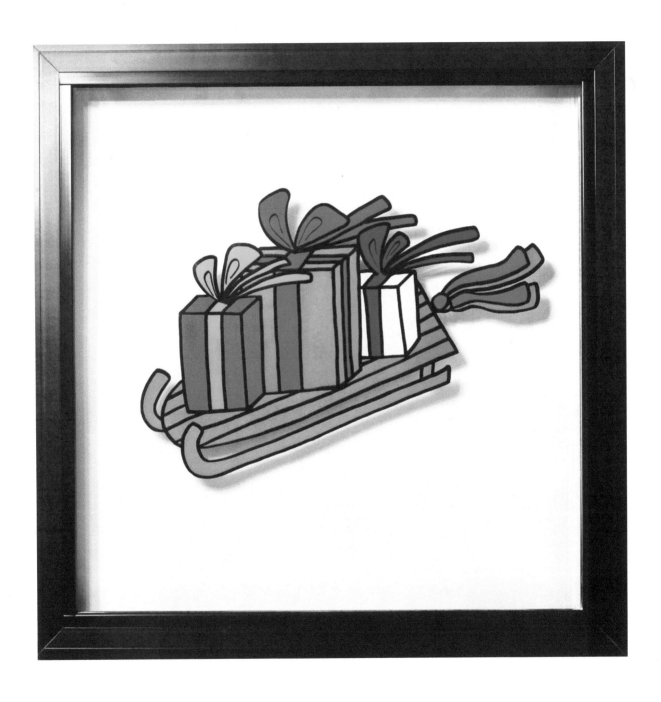

# Template Design 8: Wreath

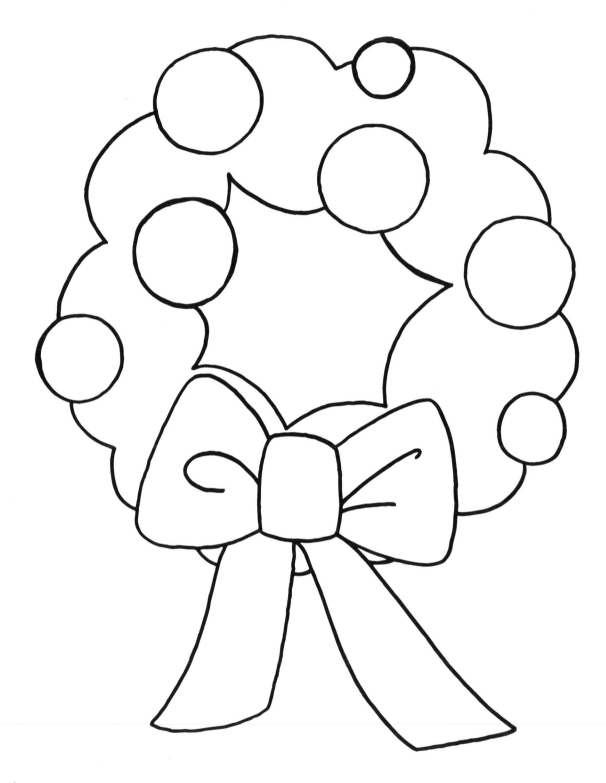

# Wreath

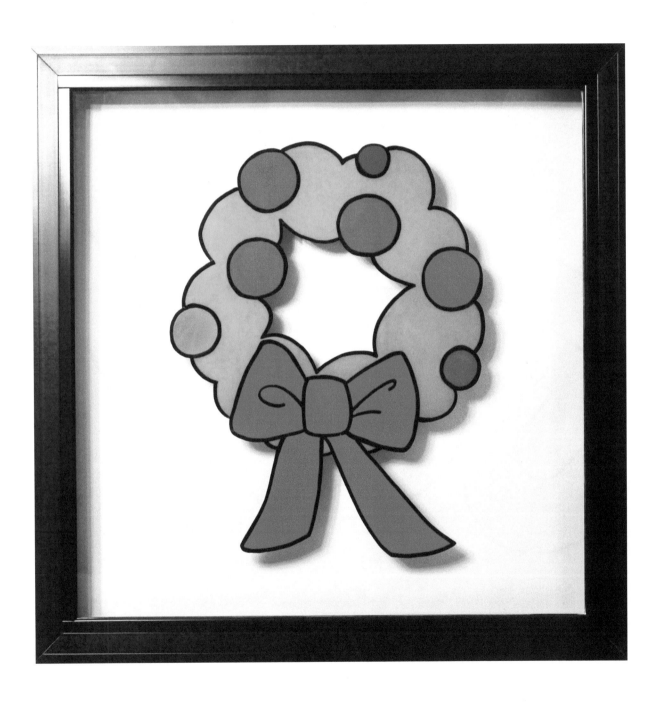

# TEMPLATE DESIGN 9: Joy Snowman

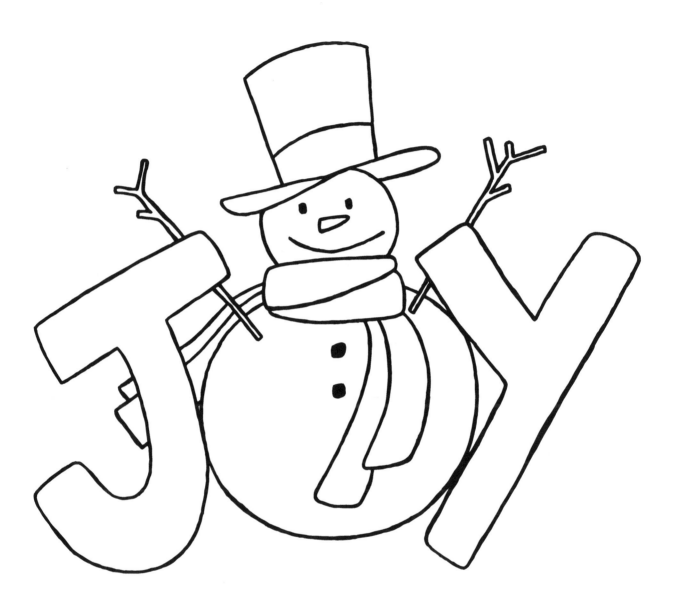

# Joy Snowman

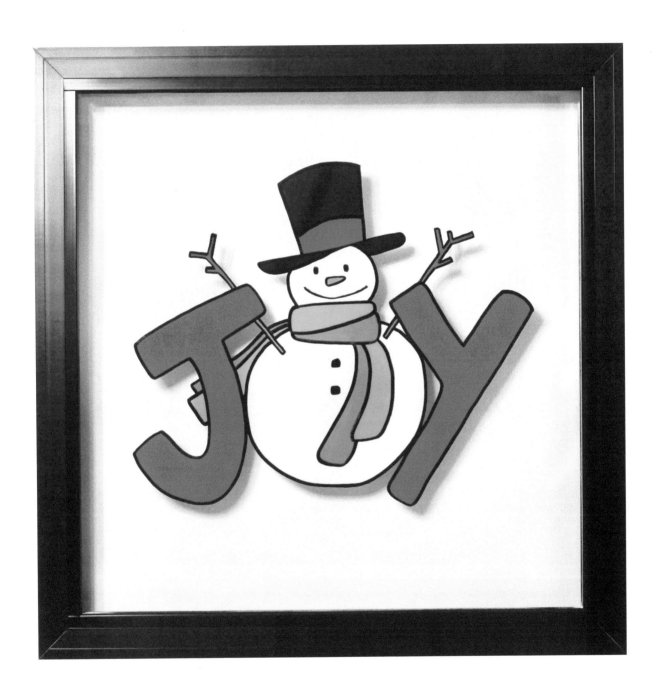

# MERRY CHRISTMAS

# MERRY CHRISTMAS

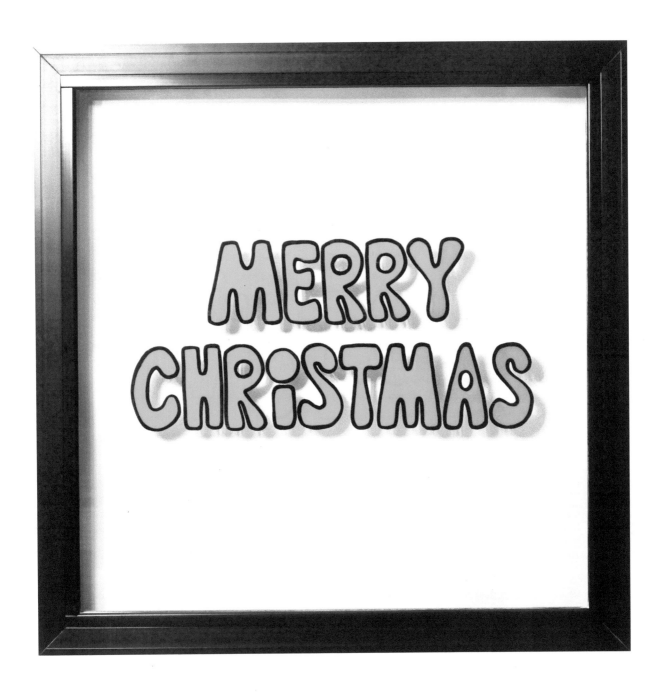

# Season's Greetings

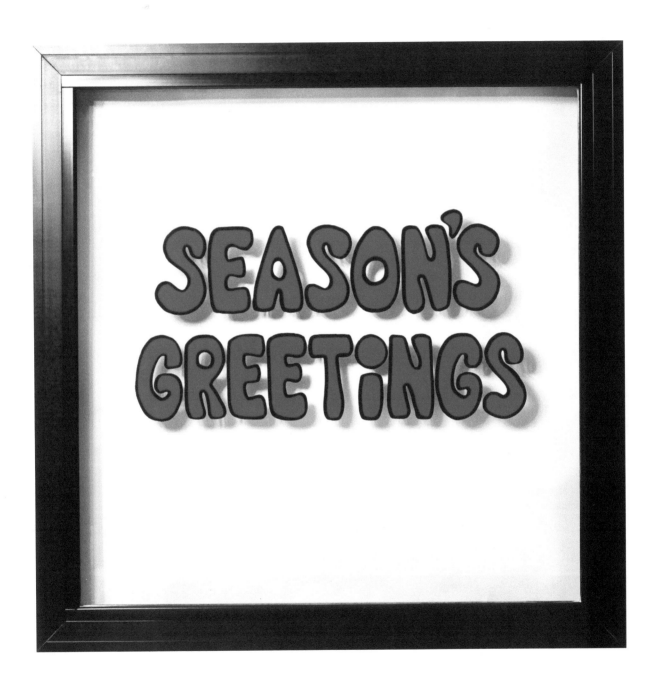

# HAPPY HOLIDAYS

# Happy Holidays

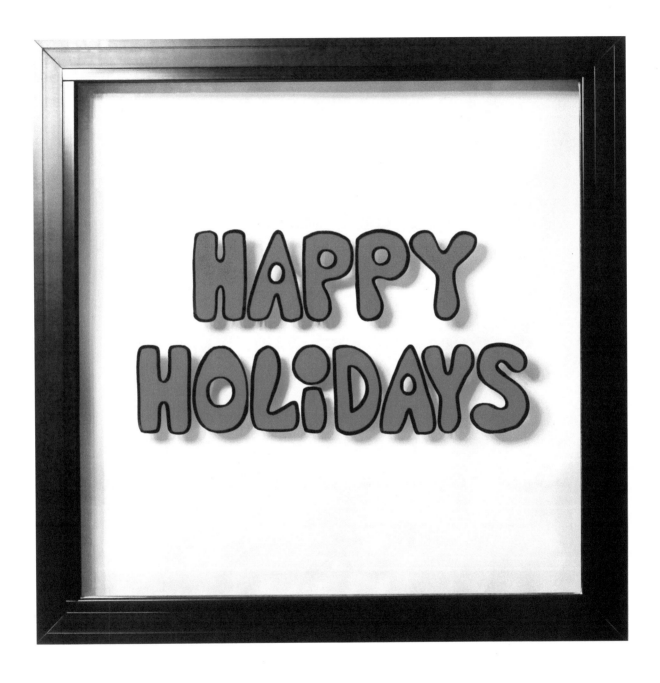

# SECTION TWO
# STEP-BY-STEP WINDOW PAINTING INSTRUCTIONS

### STEP #1: GET READY TO PAINT

### STEP #2: PLACE YOUR TEMPLATE

### STEP #3: TRACE THE TEMPLATE DESIGN

### STEP #4: COLOR THE DESIGN WITH PAINT

### STEP #5: ADD FESTIVE DETAILS

# STEP #1: GET READY TO PAINT

It's time to dig into the practicalities of holiday window painting, so that you can create some colorful holiday magic of your own. These step-by-step instructions explain how to: get ready to paint, place your template, trace the template design, color the design with paint, and add festive details.

Windows will be your canvas as a holiday window painter. You'll paint windows in all shapes, sizes, and combinations. For each painting, you'll want to get ready by envisioning your final product and creating a window painting plan.

It's okay to keep it simple. You can simply choose a template design from this book that fits the window you intend to paint. It can be nice to let a single design or some lettering stand alone. If you'd like to get more creative, you'll have the opportunity to customize something unique for each window painting adventure. Just mix and match design and lettering templates, or create your own. You can add snowflakes or other festive details if you'd like.

IMPORTANT NOTE: Work only on real glass windows. Most plexiglass and tinted windows are easily stained by tempera paint, paint pens, liquid chalk, and dry erase markers. Test washability.

Before starting each window painting, roughly sketch your envisioned window painting on paper [STEP 1A]. Begin by sketching the window layout. Take into consideration anything blocking part of the window. Then place all your window painting design elements within the window frame to create the overall design. Sketches can be used as a tool to shape your vision. There's really no right or wrong here. You have creative latitude. The options are endless!

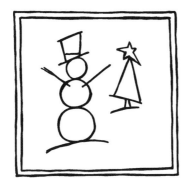 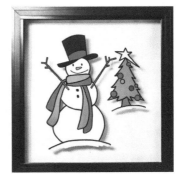

STEP 1A: Sketch Your Envisioned Painting on Paper

Once you're ready to paint, get your window painting supplies ready. Be sure you have plenty of paintbrushes and paint. Have an empty sink ready to clean your paint brushes.

Get out your chosen template. Remember, on your templates, your line drawings should be printed in reverse, as mirror images, so they appear backward on the paper templates. This will allow you to trace the backward image onto the inside of glass windows. The image will appear correctly oriented outside. This is especially important with lettering, which should read backward inside, and read correctly outside.

As you prepare to start painting, it's important to protect your surroundings from spills and other potential damage. Place your drop cloth by the window you'll paint. Be sure to cover the window sill. You can keep the drop cloth in place by using masking tape to tape it to the window, or you can use the weight of a securely closed pint bottle of paint to keep the drop cloth on the windowsill.

Set up your step ladder, which can double as a stool while you paint. Use window cleaning spray and paper towels to clean both sides of the window you'll paint until they sparkle. Have paper towels or a rag handy to clean up any messes along the way. Be sure you have a trash can or bag handy too.

Stand back and look at the window or windows you're about to paint. Thoughtfully consider your holiday window painting plan to ensure your vision supports maximum artistic impact and aesthetic taste. Now you're ready to get started.

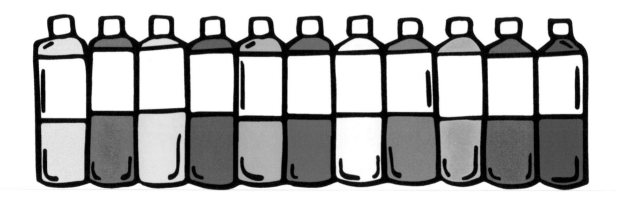

# STEP #2: PLACE YOUR TEMPLATE

Once you have a window painting plan and you're set up, you can place your template on the window. For the sake of simplicity in this example, let's focus on painting the "Snowman and Tree" template design (page 18).

On the 35" square window pictured, a 28" template is a perfect fit. Prepare your window on both sides by cleaning it with window cleaner spray and paper towels. Your window painting "canvas" should be clean and dry. Be sure to place all your used paper towels directly into a garbage bag or can, so they don't create a mess.

Now you can place your template [STEP 2A]. Use masking tape to tape your template to the outside of the window with the printed design facing indoors. The non-printed side of the template will be facing outdoors. Use a step ladder and yardstick, if needed, to ensure the template is centered, straight, and well-positioned within the window frame.

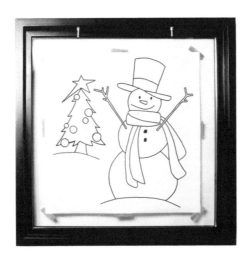

STEP 2A: Tape Template to Outside of Window with Line Drawing Facing Indoors

Now that your design template is taped to the outside of the window, go inside where it's warm, where you'll draw and paint.

# STEP #3: TRACE THE TEMPLATE DESIGN

At this point, you have your design template taped to the outside of the window. Using your 8mm black paint pen, on the indoor side of the glass, carefully trace the black lines from your template onto the glass [STEP 3A].

Black-colored paint pens were used for all the demo painting photos in this book, because black contrasts nicely with the white background in the photos. In real life, white paint pen outlines can look fantastic too, especially on darker lettering.

There are alternatives to paint pens, including dry erase board pens and liquid chalk markers. Paint pens are my favorite though, because the lines they draw are thick, opaque, and least likely to smear.

Here are a few additional tips. If you are right-handed, as much as possible, draw your black outlines from the upper left corner to the lower right corner [STEP 3B]. If you're left-handed, do the opposite. This will help you avoid smearing the paint pen lines.

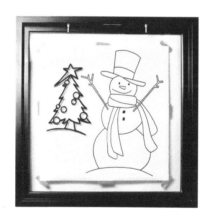

STEP 3A: Draw Outlines with Paint Pen

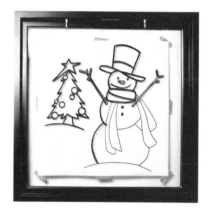

STEP 3B: Avoid Smearing Paint Pen Lines

Get eye-level and squared up with whatever you're drawing when using a paint pen, so you can trace your template as exactly as possible on the glass. Some double-paned glass is as much as 1" thick, which can make tracing your templates a little difficult. Draw slowly and deliberately to get the best outcome. Use a ladder or step stool to adjust your height and keep your eyes lined up with the drawing.

Keep these ideals in mind, and do your best. The result will be complete black outlines of your picture design on the window that matches your template [STEP 3C].

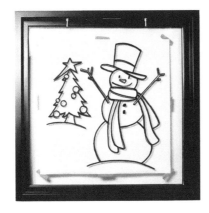

STEP 3C: Outlines Match Template

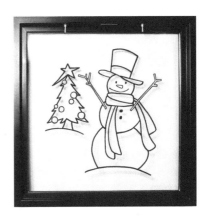

STEP 3D: Remove Template

Once you're finished drawing, your paint pen lines should be dry within minutes. Scrutinize your work and make sure you've traced every line. Then you can go outside and remove your template from the window [STEP 3D]. Carefully remove the tape from the template. Roll up the template and secure it with a rubber band for later use. Or you can leave the template on the window until the painting is complete.

Now you can go back inside and start filling in the black lines with colorful paint to make the painting come alive!

# STEP #4: COLOR THE DESIGN WITH PAINT

Now that your black outlines are complete and dry, you can fill in your picture design with colorful paints [STEP 4A]. It's just like painting a picture in a coloring book! Remember to paint on the indoor side of the window.

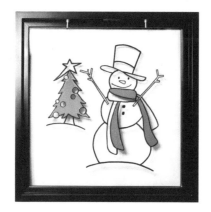
STEP 4A: Begin Painting Indoors

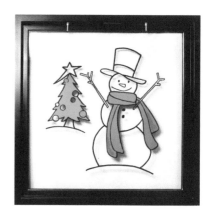
STEP 4B: Paint One Color at a Time

I'd suggest painting one color at a time with plain tempera paint. There's no need to add water. Start with any color you want and then paint everything that needs to be that color [STEP 4B].

Be careful to paint the correct colors in the right places [STEP 4C]. Decide on your colors ahead of time. You can use this book as a reference. Or use your own marker-colored portfolio pictures as a reference, which will be described later in section three of this book.

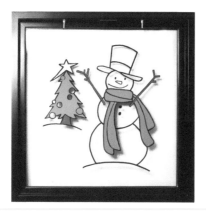
STEP 4C: Carefully Choose Colors

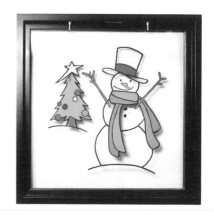
STEP 4D: Paint Pleasing Brush Strokes

Fill your brush with paint. Support and steady your hand against the glass when possible to create thick, smooth paint strokes inside the black paint pen lines. Aim to make your paint brush strokes pleasing to the eye [STEP 4D].

Use a clean paintbrush for each color. Consider designating certain brushes for each paint color [STEP 4E]. Place your used paint brushes on a paper towel or rag, or in a cup, to avoid messes. Wash your brushes mid-painting if you run out of clean ones. Rinse all the bristles thoroughly with plain water and no soap. Make sure you leave the sink clean. Be sure to dry the bristles completely with a rag or paper towel, before using them to paint again, so they don't water down your paint.

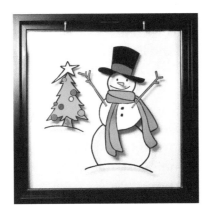

STEP 4E: Designate Brushes for Colors

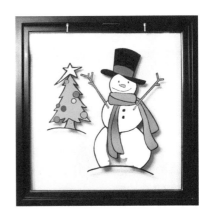

STEP 4F: Systematically Paint Each Color

Systematically work your way through each color of paint, until the entire picture design is colored in [STEP 4F].

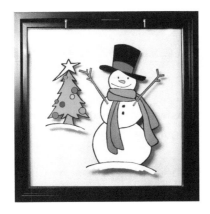

STEP 4G: Paint Snowy Hills

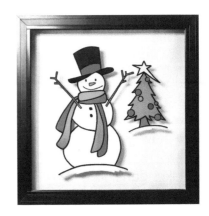

STEP 4H: Front Outdoor View of Finished Painting

When painting snowy hills, carefully paint several long, clean lines of white [STEP 4G]. Start by painting a long white line underneath the black hill outline. Then paint consecutively shorter white lines underneath. Make them slightly off center and wonky. When you're done, go outside, and take a look at your artistic work [STEP 4H].

# STEP #5: ADD FESTIVE DETAILS

Details like snowflakes are an optional finishing touch. Once your holiday window painting is complete, it's pretty simple to add a flurry of snowflakes or other festive details to fill in blank window space [STEP 5A].

In real life, on windows, white snowflakes stand out nicely against a darker indoor background. The cover of this book shows an nice example of white snowflakes in contrast with a darker backdrop. Another good option is custom-mixed light blue snowflakes, like the ones pictured on this page.

To paint your snowflakes, use a thin or medium paintbrush, anywhere from size 2 to 4. Load the brush with a small amount of white or custom-mixed light blue paint. For each snowflake, paint a "+" and an "x" on top of each other. Use fast, light, swift movements for each brush stroke. The result will be delicate and wispy - kind of like real snowflakes.

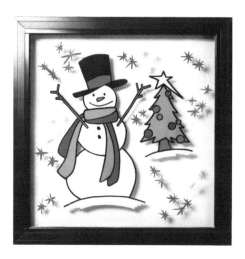

STEP 5A: Consider Adding Festive Details like Snowflakes

Alternatively, you can draw snowflakes with a paint pen, instead of paint. When using a paint pen to draw snowflakes, use the same type of soft movements.

Your snowflakes don't have to be perfect and uniform. It's best if they're each unique and have a little wonky artistic flair. Little details like snowflakes add a nice touch to window paintings, because they add depth and tie everything together whimsically. They can also expand the overall size of your painting to fill a window, and nearby windows too, if you'd like. The resulting effect is festive and breezy!

In addition to snowflakes, you might consider other festive details to add to your paintings. Good options include poinsettias, candy canes, and holly, among others.

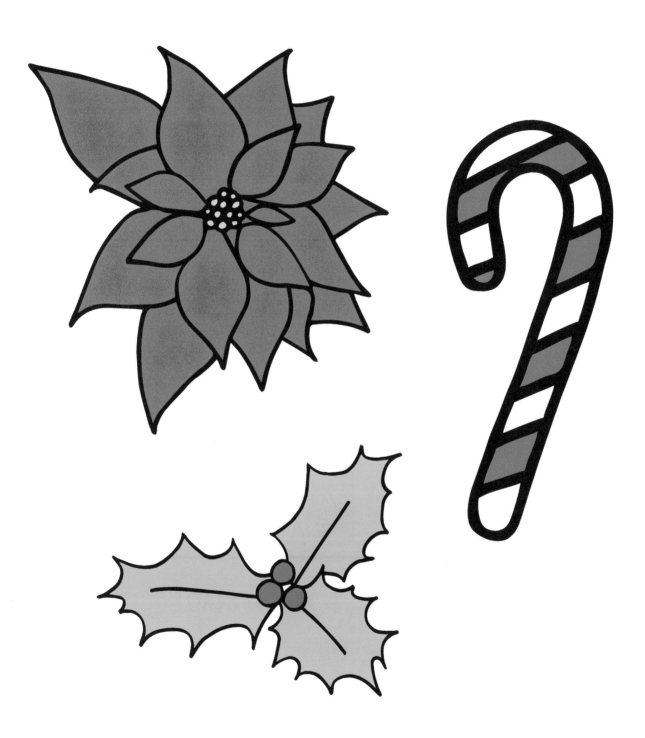

When you've completed your holiday window painting, go outside, stand back, and admire your work. Be sure to take multiple pictures of your finished masterpieces!

# SECTION THREE
# ADDITIONAL KEYS TO SUCCESS

## Mix Color

## Practice Painting

## Create a Portfolio

## Make the Magic Happen

# MIX COLOR

You'll sometimes need to mix colors to get a non-standard paint shade. Keep at least one empty paint jar in your toolbox to mix paints whenever the need arises. Use a paintbrush to stir mixed colors into a uniform hue [Figure 19]. Remember that a little bit of paint goes a long way when color mixing. Feel free to get creative when mixing colors. The entire color spectrum is beautiful and infinite.

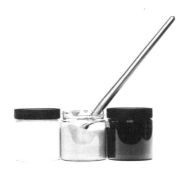

Figure 19: Mix Paint Colors in an Extra Jar

Here are some colors I frequently mix.

**Gray:** Start with white paint. Mix in drops of black paint, until you get your desired shade of gray.

**Skin Tones:** You can mix various skin tone shades using different combinations of black, brown, red, yellow, and white. It helps to have a visual example of the color hue you are trying to achieve. You might use your own skin tone or a photo as your example. Start with about a couple tablespoons of the main color. Then carefully adjust the hue by adding drops of other colors, mixing with a paintbrush as you go.

**Light Blue:** Start with white paint. Mix in drops of blue paint, until you get your desired shade of light blue.

# PRACTICE PAINTING

As you fine-tune your craft, you'll want to get some practice holiday window painting. Procure your painting supplies, create your design templates, and try window painting for yourself at home. Practice, practice, practice!

IMPORTANT NOTE: When you use a lettering template, you'll want to double check to be sure the words read correctly outdoors. Keep in mind you'll be painting indoors, so you'll actually be painting the lettering backward [Figure 20].

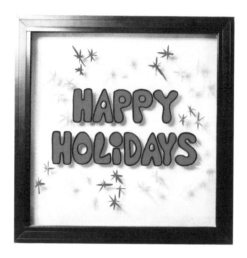

Figure 20: Practice Painting

Experiment using your templates, tempera paints, and paint pens. Seek out quality artistic supplies, and experiment with line drawing and painting techniques. Some things can only be learned by trying them yourself. Using the guidelines in this book, create your own systems, and break some rules. See how things go. Don't expect perfection. Allow your skills to develop with practice.

A small sustained effort over time will pay you back with abundant new artistic skills. It'll take some discipline, patience, and persistence. It'll be worth it. You'll keep improving over time. Bring love and focus to your art, and you'll see your skills multiply. It'll be a nice, colorful surprise!

Paint the windows in your home to celebrate the holidays. Paint windows for your family and friends. Window painting is fun alone. It's also a fantastic activity to share with good company. If you have people who want to paint with you, by all means, join forces. You might even want to throw a window painting party!

Consider buying a loose framed glass window from a hardware store to practice on, like the one in this book's demo photos. Use serious caution; they are heavy. For a lighter-weight option, you can practice on the glass inside a large picture frame. Or just paint the existing windows in your life.

As you practice, notice how long it takes you to paint. Most paintings take about 3 hours to complete, including setup, painting, and cleanup. But some paintings can take less time, or much longer, depending on the size, complexity, and how quick or slow-and-methodical you are.

If you really don't like how a painting is progressing, you can start over completely by removing all the paint. Just spray the entire window painting with window cleaner and clean it off thoroughly with paper towels. Be sure to put these paint-covered paper towels straight into a garbage bag or can, so they don't make a mess. You can also fix small window painting errors and drips. Just wait until the paint dries, then carefully and cautiously use a razor blade to scrape off the mistake, and then repaint.

While it's always good to strive for excellence, be kind to yourself, and remember that all window paintings are perfectly imperfect. It's part of their charm and what makes them art.

# CREATE A PORTFOLIO

Consider making a portfolio of your holiday window painting masterpieces. This type of art is temporary. Photographs will make your artistic work last longer. Take pictures of all your window paintings. Get a few photos of yourself standing next to your completed paintings. List the year, place, and a short memory note. You'll love having these pictures to share with family and friends and to look back on in the future.

Your portfolio will look a lot like a coloring book. To create your portfolio, all you need is a three-ring binder, standard 8.5" x 11" paper, and some clear plastic sheet protectors.

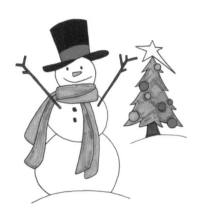

Figure 21: Colored Template Design on Paper

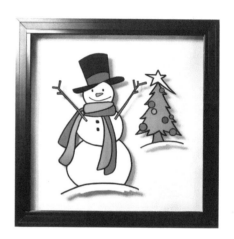

Figure 22: Photo of Window Painting

I'd suggest including small line drawings of each of your template designs, so you can easily remember your painting options. You can copy the line drawings in this book or create your own, as you fill your portfolio. Color in the line drawings with markers, showing your intended paint colors {Figure 21}. Then as you paint windows and take pictures, add photos to your portfolio, so you can have a reminder of your painting skills in the future [Figure 22].

If you'd like to do holiday window painting professionally, your portfolio will come in handy. The line drawings and photos will show interested parties your artistic abilities and help customers imagine their own painted windows. A portfolio is a good way to show your window painting options quickly, easily, and professionally.

However, even if you're painting just-for-fun, portfolios are a wonderful way to neatly package your window painting wonders. It's always nice to have a neat little book that showcases your best work.

# MAKE THE MAGIC HAPPEN

Have a fabulous time with your holiday window painting! You'll create all kinds of holiday happiness. Get out your supplies and paint some windows at home and in your community. Spread some holiday cheer, love the process, and enjoy developing a new artistic skill that will brighten lives.

Your disciplined artistic efforts will pay off. You'll dazzle yourself with your perfectly imperfect holiday window paintings. Your results will be excellent and satisfying.

Your whimsical, winning, festive paintings will make the world a brighter, more colorful place, and that's an absolutely beautiful thing!

Allow yourself to generate positive feelings in abundance. While you window paint, recognize that you are living the good life. You're talented. You're artistic. You're making the magic happen. You're sharing your creative gifts. You're daring to paint holiday joy all over the place!

Relish your new skill. Have a grand time! Holiday window painting exists purely to delight us all. So enjoy yourself - thoroughly - as you develop your own unique brand of colorful holiday magic!

Now go paint!

# Appendices: Resources

**APPENDIX 1: FREE TEMPLATE DESIGN PDF FILES**

This book includes 12 free-use window painting template designs, They are the black-and-white line drawings shown in this book on pages 18-40. These 12 free template designs are available online as PDF files at the following website.

TheHolidayWindowPaintingBook.com

These PDF files are free and free to use. You can email the files directly to a printer to create window painting templates. Just request enlarged paper prints of the line drawing designs, which you can use as holiday window painting templates. Consider lamination for extra durability. You can also scan and print the line drawings directly from this book.

All the template design PDF files and images in the book contain a message giving permission to print. You are free to copy, print, enlarge, and use all the line drawing images for any purpose, including templates for professional holiday window painting. REMEMBER: Print the line drawings in reverse, as mirror images, so they appear backward on the paper templates.

**APPENDIX 2: WINDOW PAINTING SUPPLY RECOMMENDATIONS**

For my current product and brand recommendations on affordable-yet-high-quality painting supplies, please visit the following website.

TheHolidayWindowPaintingBook.com

Quality window painting supplies will greatly improve your ability to create excellent window paintings. Products are always changing and evolving. I'm constantly exploring what's available in terms of washable tempera paints, paint pens, paintbrushes, and other supplies. My goal is always to find the best painting supplies at the lowest prices.

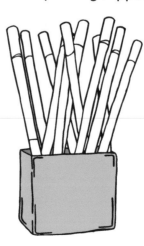

# THANK YOU!

Thanks to YOU for reading this book. I hope what I've written here makes you feel empowered, knowledgeable, and motivated to create your own holiday window paintings. I hope you feel happy and ready-to-go.

Thank you to my wonderful husband, Guy Craig, for originally suggesting I write "The Holiday Window Painting Book". He provided creative ideas, brilliant editing, confidence in my abilities, practical support, and big window-lifting muscles as I wrote this book.

Thank you to our son, Kenneth Craig, for his enthusiastic appreciation of my window paintings. Our boy is a budding creative talent who loves colors, painting, and artwork just as much as I do. As Kenneth likes to say, "let's paint!"

Thank you to my dad, Dennis Simpson, who taught me how to do holiday window painting. I love painting with him. He's talented, hard-working, and he loves to celebrate.

Thank you to my mom, Katie Simpson, who is the most practical and wise person I know. Her guidance helped me stay authentic and grounded in reality as I wrote this book.

Thank you to Adam Rolison for allowing me to borrow his original character Secret Terry in this book, the mischievously lovable mascot of all-inclusive holiday gift exchanges everywhere.

Thank you to my generous and detail-oriented family and friends who helped me revise, fine-tune, proofread, and design this book: Adam Rolison, Angie Daschel, Bec Katz, Cameron Lambright, Dennis Simpson, Erica Lambright, Guy Craig, Heather Cadwallader, Joan Frazer, Joseph Wykel, Kate Wells, Katie Simpson, Lance Hegner, Michael Goulart, Paula Williams, Rebecca Green, and Susan Severance.

Big thanks to my fabulous family and friends who've encouraged me in holiday window painting and book writing. Every single one of you is much appreciated!

Thank you to my communities at TheHolidayWindowPaintingBook.com, Facebook, LinkedIn, Instagram, Pinterest, Twitter, and ThoughtsOnTheGoodLife.com for the inspiration, conversation, and motivation.

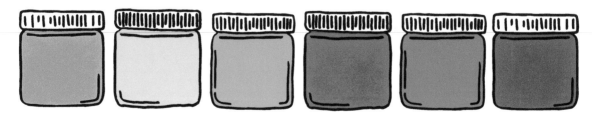

# ABOUT THE AUTHOR

I'm Sarah Craig, author of "The Holiday Window Painting Book". I'm an indoor holiday window painter. Window painting is a delightful artistic experience. I wrote this book to show you how it's done.

I live in beautiful Portland, Oregon with my lovable husband, Guy, our adorable son, Kenneth, and our sweet tortoiseshell cat, Taxi. I work full-time as an international medical salesperson. I'm also an armchair philosopher, art lover, photographer, nature enthusiast, walker, talker, and drinker of coffee and wine.

I created the website **TheHolidayWindowPaintingBook.com**. It features this book, my original window painting design templates, recommended supplies, and information on the practicalities of holiday window painting.

I also produce the website **ThoughtsOnTheGoodLife.com.** It's a personal development blog on the art of living the good life. It features personal challenges, personal development book recommendations, my thoughts on the good life, and side income projects. This website is also home to my publishing company, Thoughts on the Good Life Press, LLC.

Thanks again for reading "The Holiday Window Painting Book". Please feel free to reach out to me at **Hello@ThoughtsOnTheGoodLife.com**. I encourage you to email me photos of your window paintings, so I can lavish praise upon you! You've got a big fan right here.

ALL THE BEST !

Sarah Craig

# INDEX

Thoughts on the Good Life
.com